COLOR LAYERING

As shown in the design below, it is best to start with the lightest colors first—in this case, light pinks. Then add a darker color, such as the orange shown. In this color sample, the next step is to add a deep pink. As a last step, you can add a color to the background. Feel free to add gradations to your color fills for a softer look or use all solid color fills for a bolder effect.

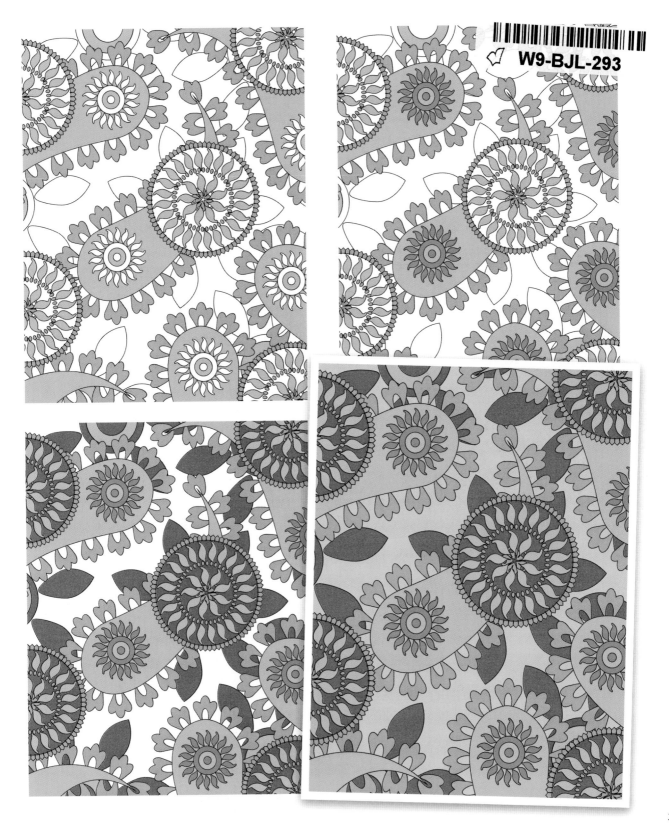

COLOR INSPIRATION

The following pages are filled with colored samples to get you thinking and imagining. First, you'll find pages full of multiple color ideas for single images, so you can see how a different color scheme and approach can make the same design look radically different. Then, you'll find several gorgeous hand-colored pieces using a variety of different art mediums by the talented artist Marie Browning. Enjoy the colorful inspiration here before you sit down to create beautiful art yourself—let your creativity flow!

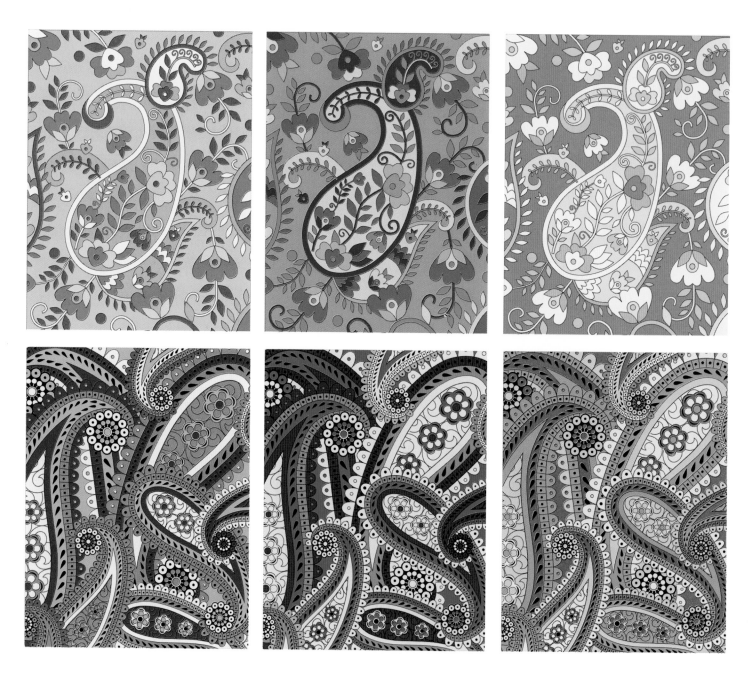

COLOR IDEAS

Patterns within patterns can be made by repeating sets of colors in repeating designs. For example, if the same motif is repeated within one design, you can approach the coloring in different ways. Check out the samples on this page for ideas.

Remember, there are no right or wrong ways to color these designs. This book was created for your enjoyment. As you are coloring, take your time, relax, and enjoy the creative and meditative experience. Each page is filled with details and forms you can choose to color in a variety of ways. Try a bright and bold color palette with solids on one page, then try a soft, pastel scheme with shading and gradients on another page. You will be amazed at the variety of results!

Color motifs all the same for a wallpaper effect.

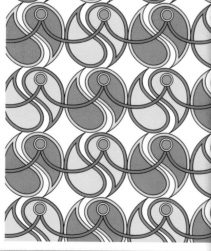

Color motifs in an alternating sequence like a checkerboard for a pattern inside a pattern effect.

Create dynamic effects by alternating the colors of the shapes in a motif so that the colors themselves form a random pattern.

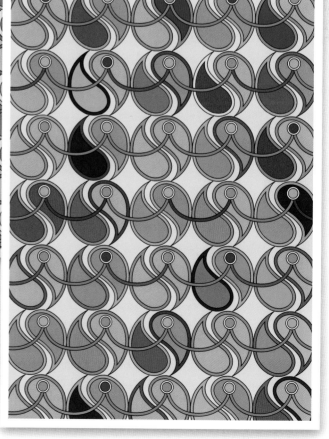

COLOR TIPS

As a designer, I love to experiment with colors and to mix techniques and mediums. For me, bright and bold always looks good. Sometimes I like all warm colors and sometimes all cool colors. Other times I randomly mix warm and cool colors together in the same design, creating a bold complementary palette.

Check out the handy color wheel below. Each color is labeled with a P (primary), S (secondary), or T (tertiary). In the very center of the wheel, you'll see a circle of lighter colors, called tints. A tint is a color plus white. On the outer edges of the wheel, you'll see a ring of darker colors, called shades. A shade is a color plus black. The colors on the top half of the color wheel are considered warm colors (red, yellow, and orange), and the colors on the bottom half are called cool (green, blue, and purple). Colors opposite one another on the color wheel are called complementary, and colors that are next to each other are called analogous. Experiment with color yourself with this quick reference page to serve as inspiration!

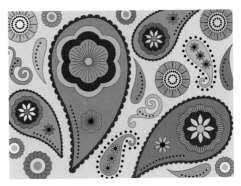
Cool colors

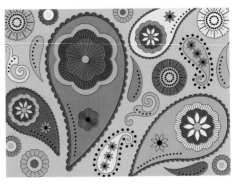
Warm colors

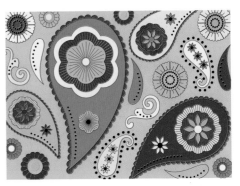
A mix of cool and warm colors

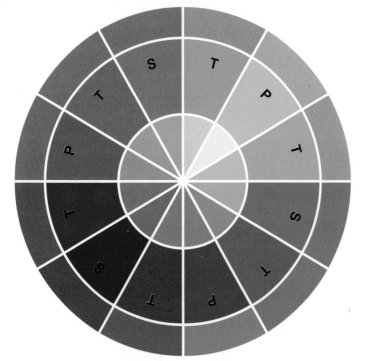

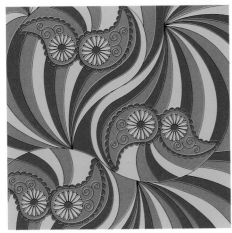

Primary colors: The primary colors are red, yellow, and blue. They are called "primary" because they can't be created by mixing other colors.

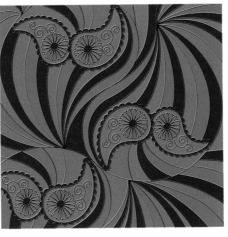

Secondary colors: Mixing primary colors together creates the secondary colors orange, green, and purple (violet).

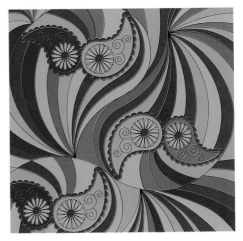

Tertiary colors: Mixing a primary color and a secondary color together creates the tertiary colors yellow-orange, yellow-green, blue-green, blue-purple, red-purple, and red-orange.

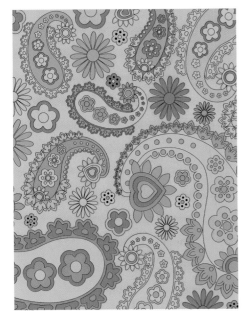
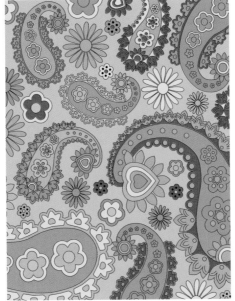
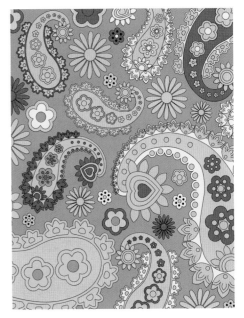
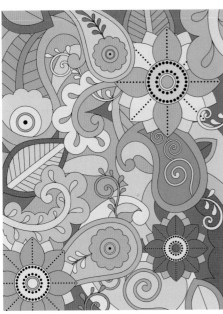
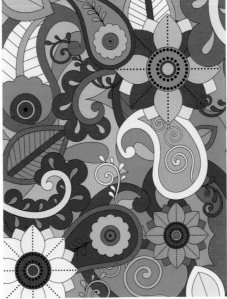
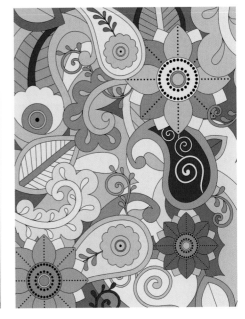
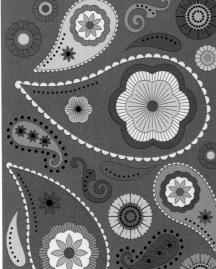

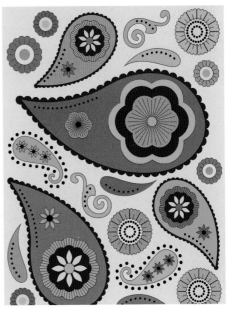

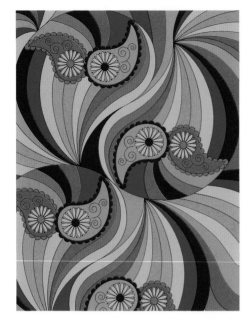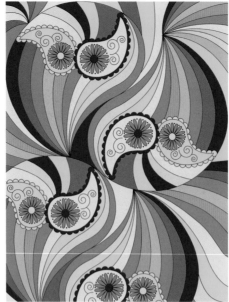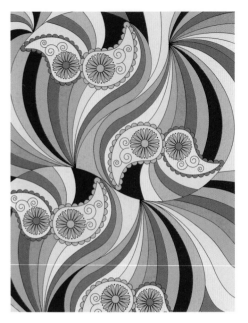
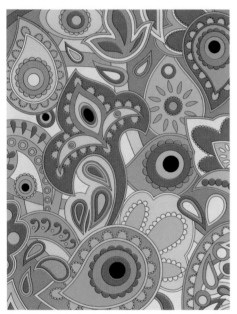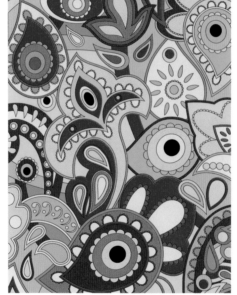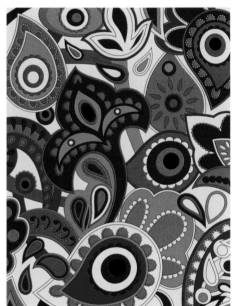
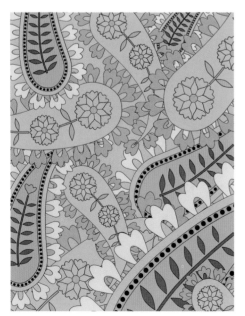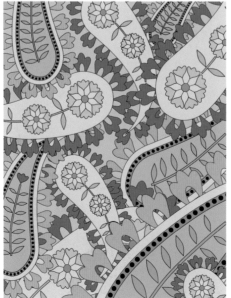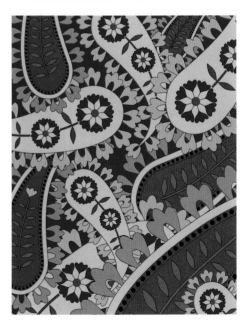

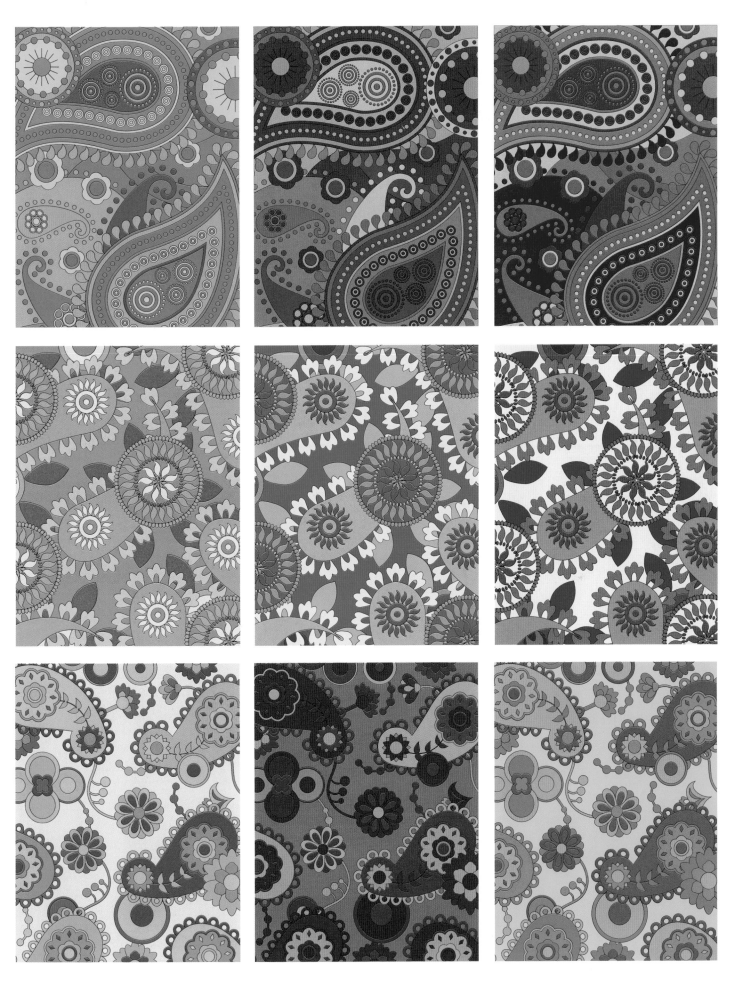

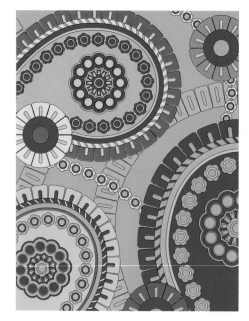
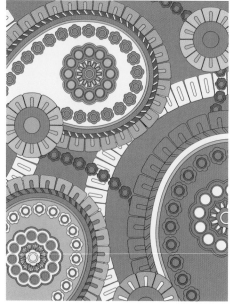
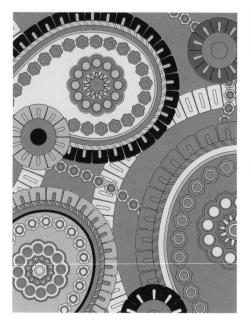
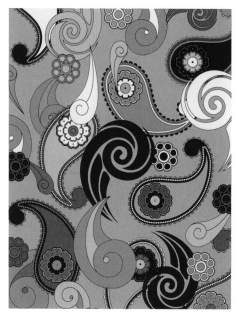
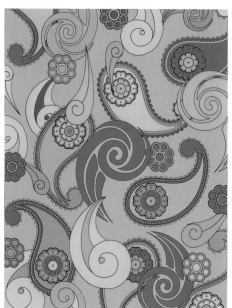
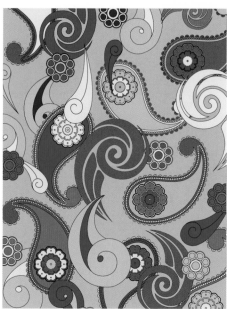
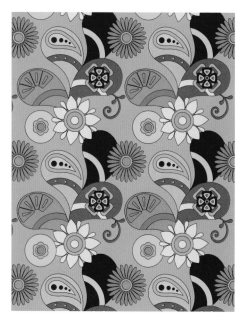
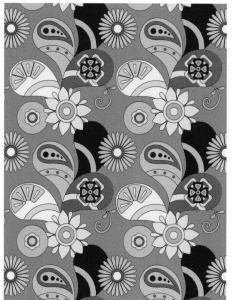
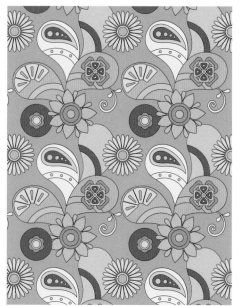

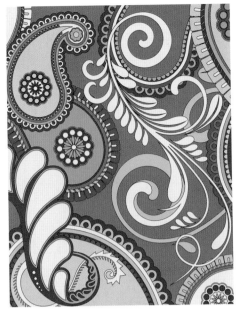
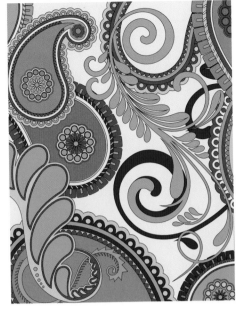
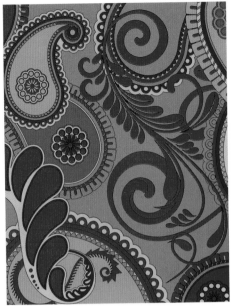
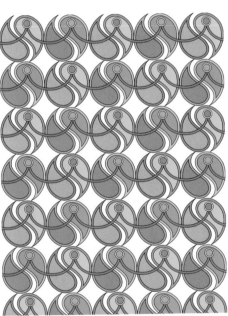
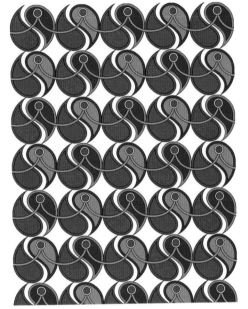
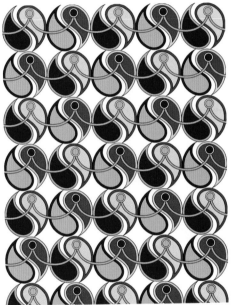
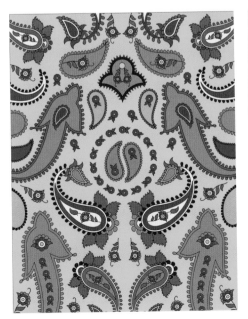
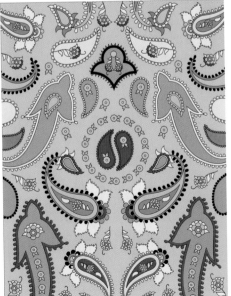
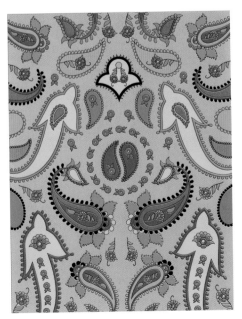

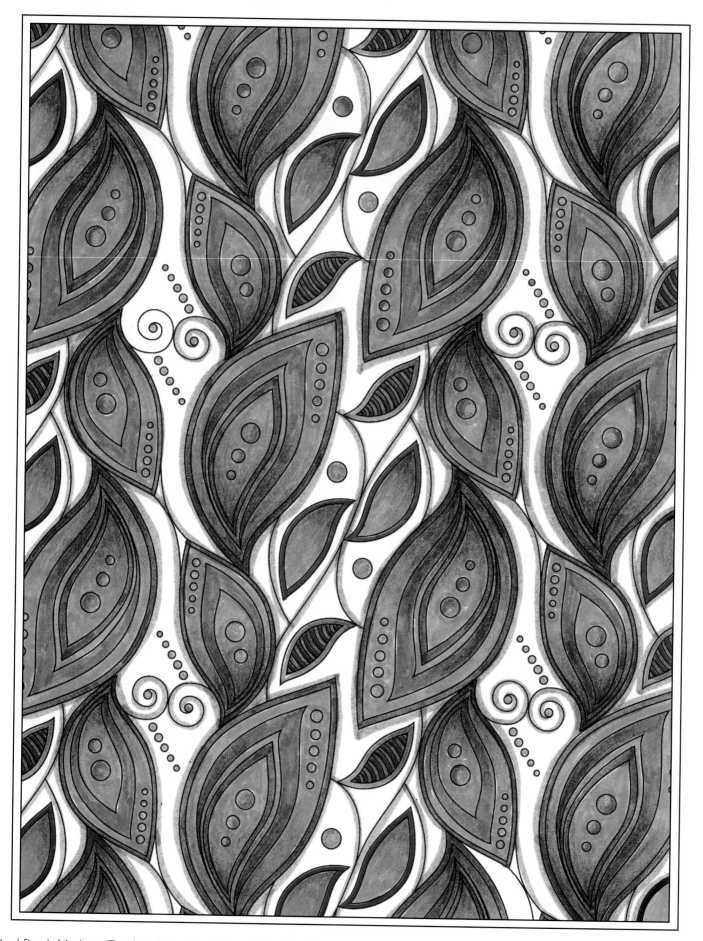

Dual Brush Markers (Tombow), Irojiten Colored Pencils (Tombow). Split Complementary Tones. Color by Marie Browning.

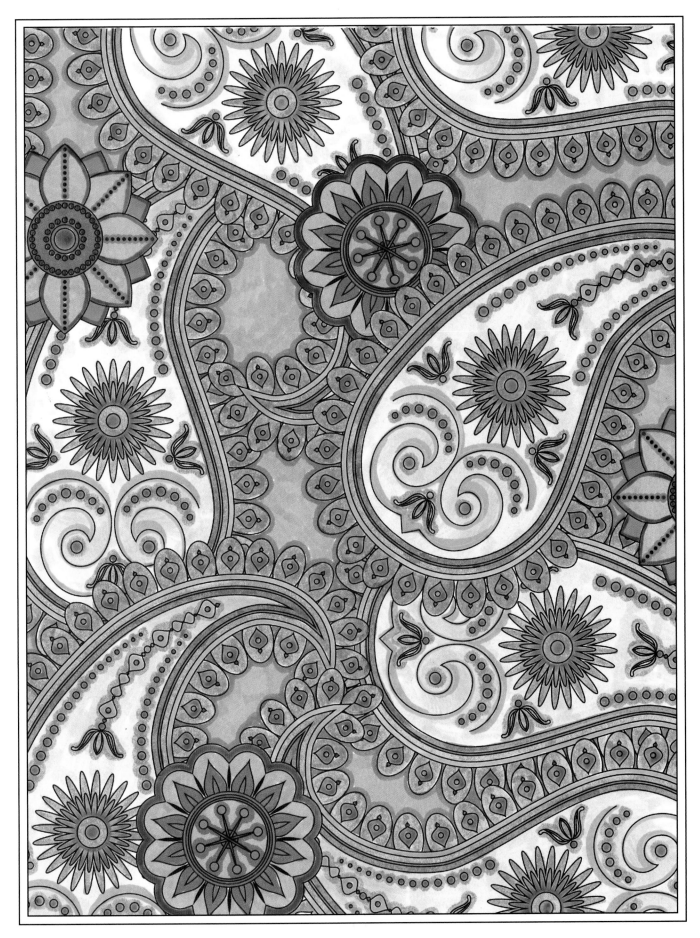

Dual Brush Markers (Tombow), Gel Pens (Sakura). Complementary Tones. Color by Marie Browning.

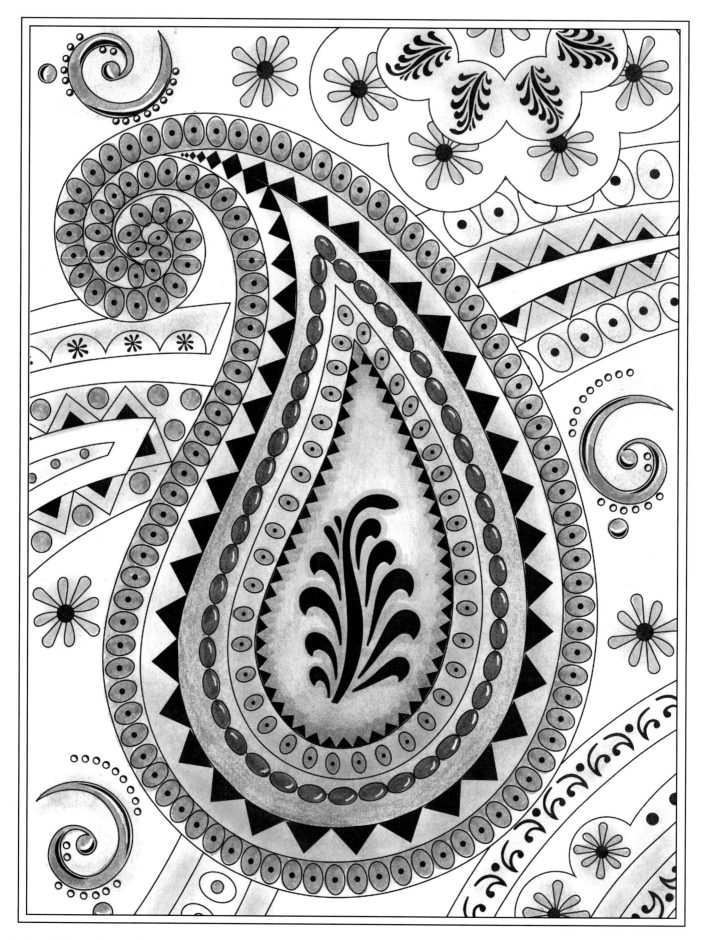

Pitt Pastel Pencils (Faber-Castell). Soft Complementary Tones. Color by Marie Browning.

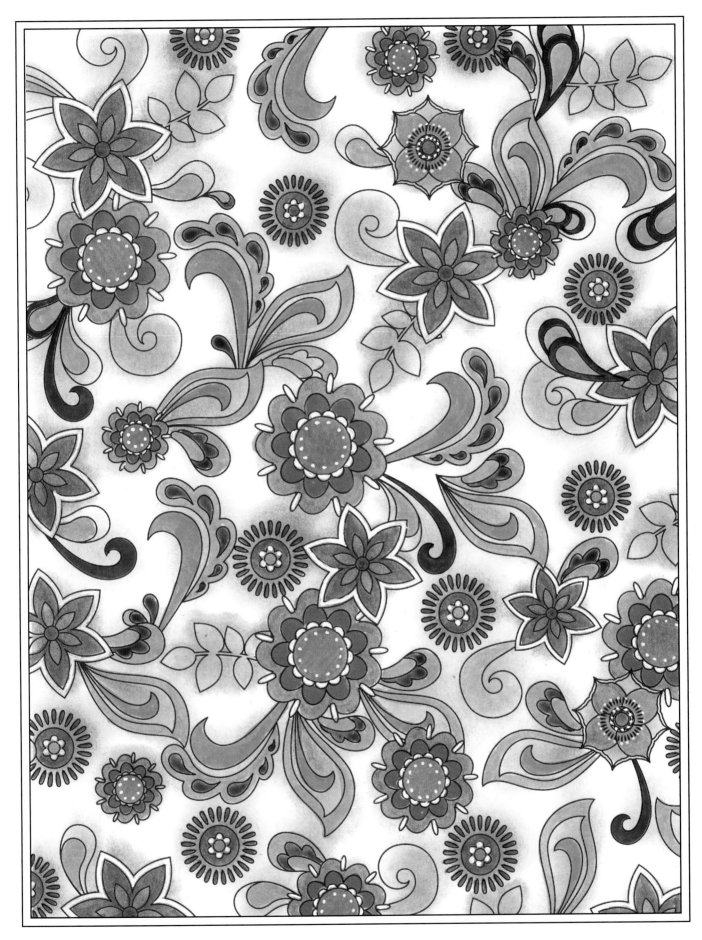

Pitt Pastel Pencils (Faber-Castell), Gel Pens (Sakura). Jewel Tones. Color by Marie Browning.

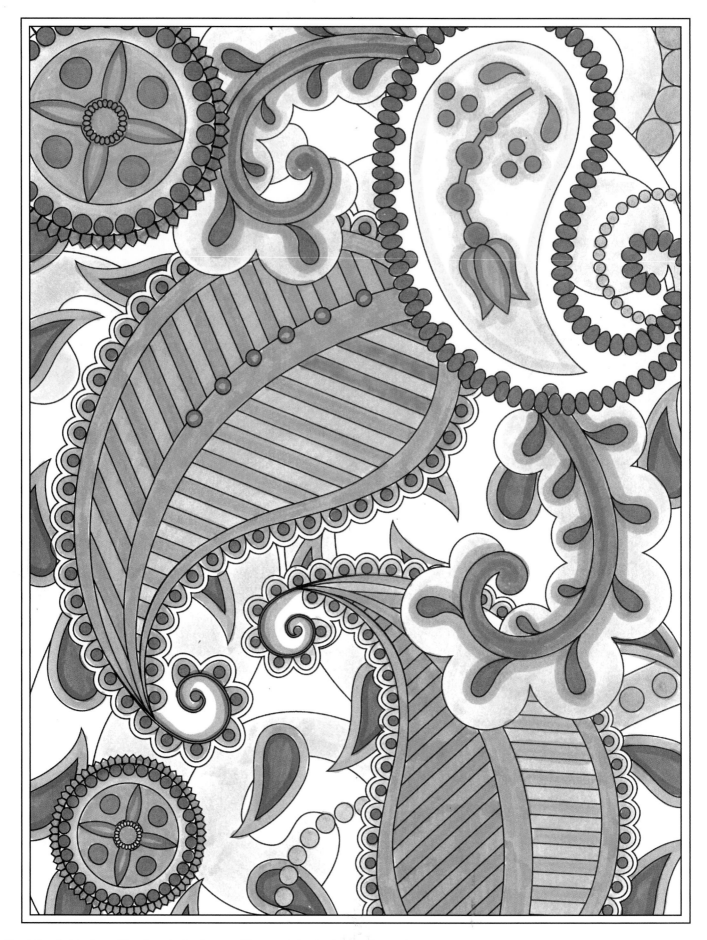

Dual Brush Markers (Tombow). Analogous Tones. Color by Marie Browning.

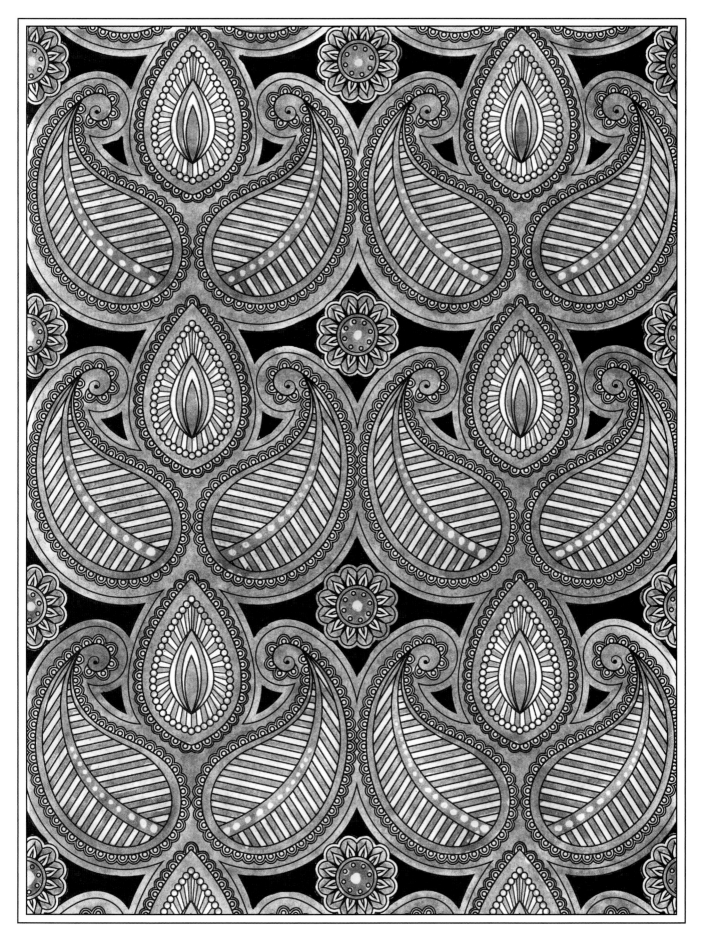

Clear Gel Pens (Sakura), Pitt Pastel Pencils (Faber-Castell). Analogous Tones. Color by Marie Browning.

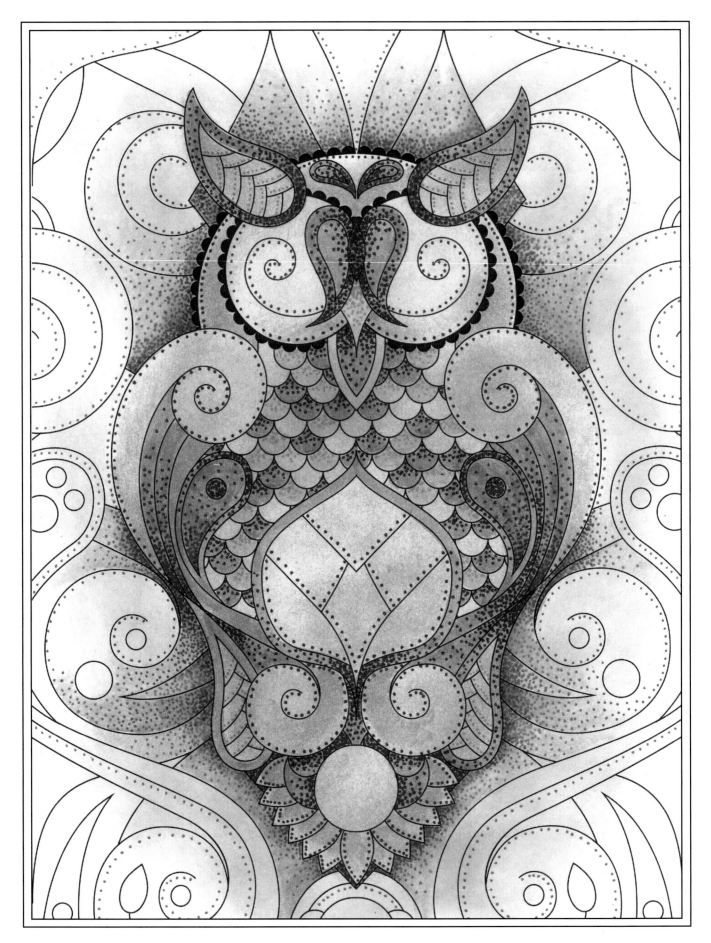

Pitt Pastel Pencils (Faber-Castell), Dual Brush Markers (Tombow). Nature Tones. Color by Marie Browning.

I have always considered myself a
free spirit with a gypsy soul.
Surrendering gratefully to
wherever life takes me.

—Melanie Moushigian Koulouris

My true self is free.
It cannot be contained.

—Marcus Aurelius

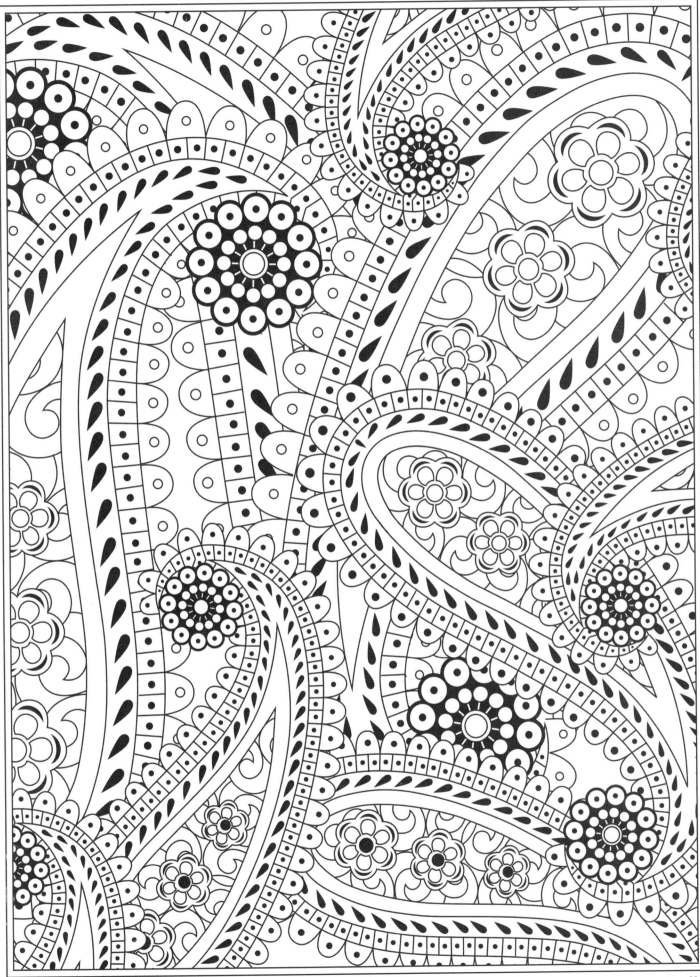

23

You belong somewhere
you feel free.

—TOM PETTY, *Wildflowers*

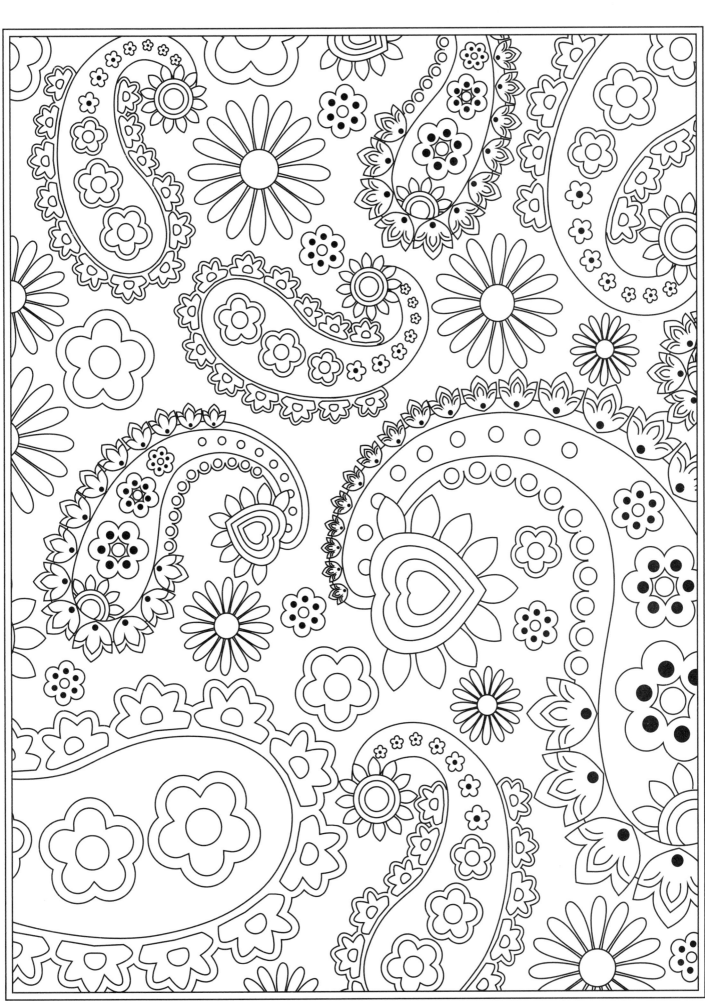

25

When you've seen beyond
yourself, then you may find, peace
of mind is waiting there.

—THE BEATLES, *Within You Without You*

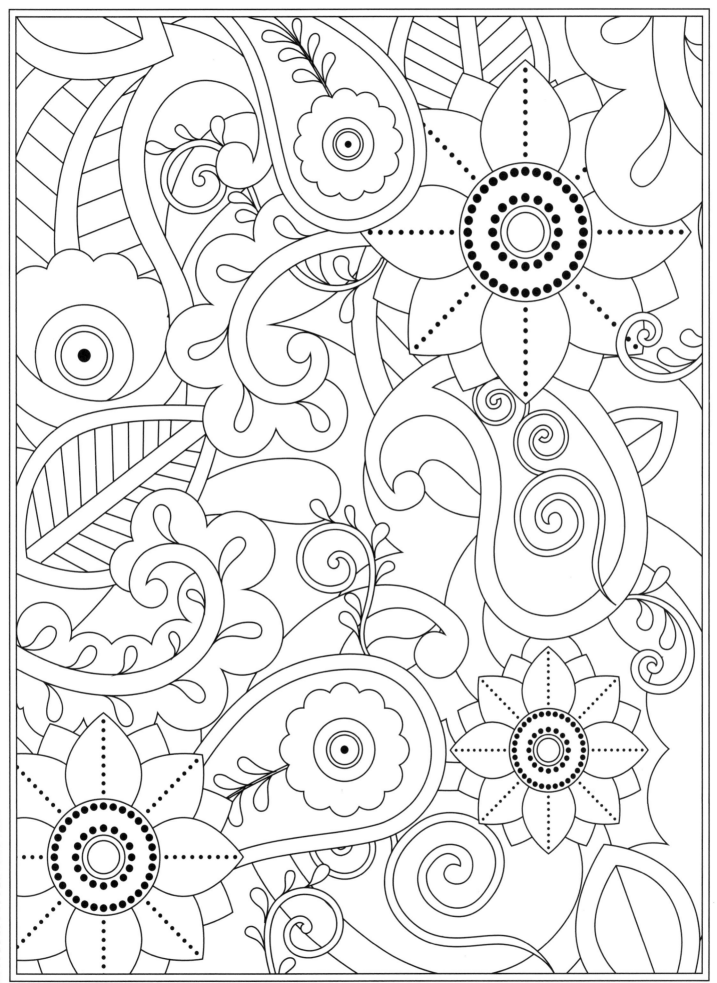

All I'm gonna do is just go on
and do what I feel.

—Jimi Hendrix

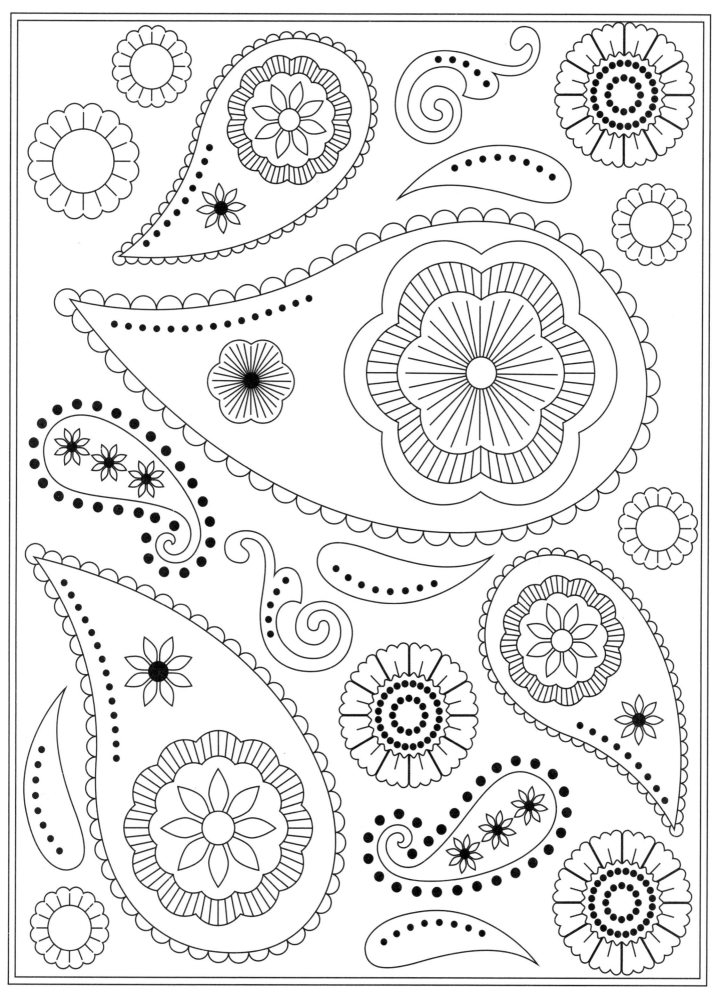

All good things are wild and free.

—Henry David Thoreau

Follow your bliss and the
universe will open doors where
there were only walls.

—JOSEPH CAMPBELL

Love is all you need.

—THE BEATLES, *All You Need Is Love*

Live, travel, adventure, bless,
and don't be sorry.

—Jack Kerouac

If you want to be free,
be free, 'cause there's a million
things to be.

—CAT STEVENS, *If You Want to Sing Out, Sing Out*

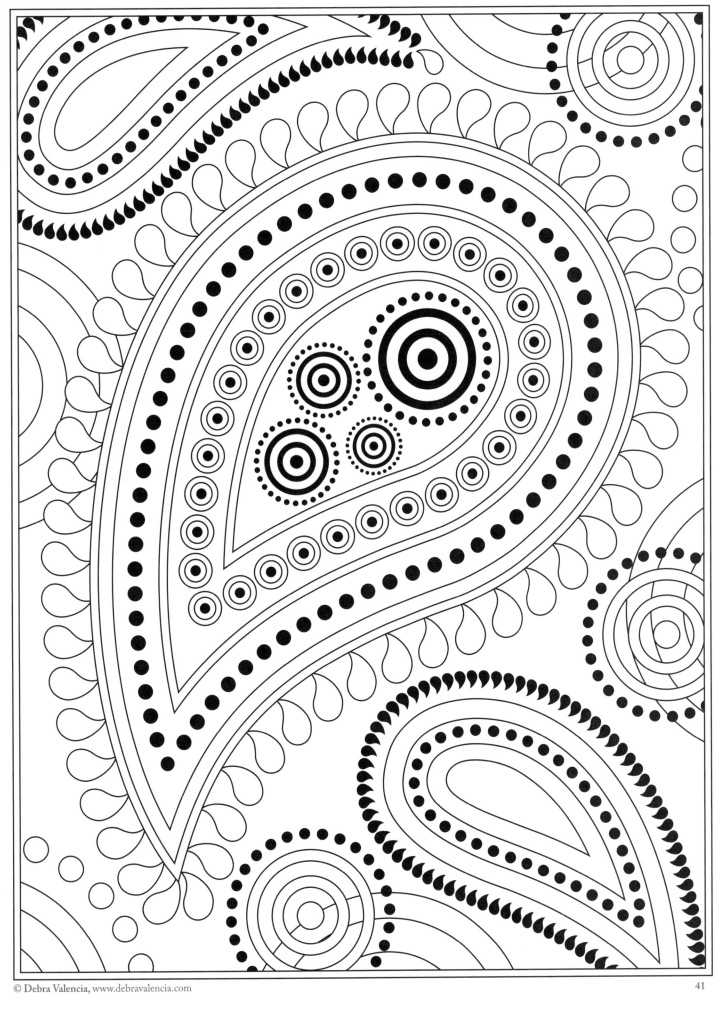

Talk to yourself like you would to someone you love.

—Brené Brown

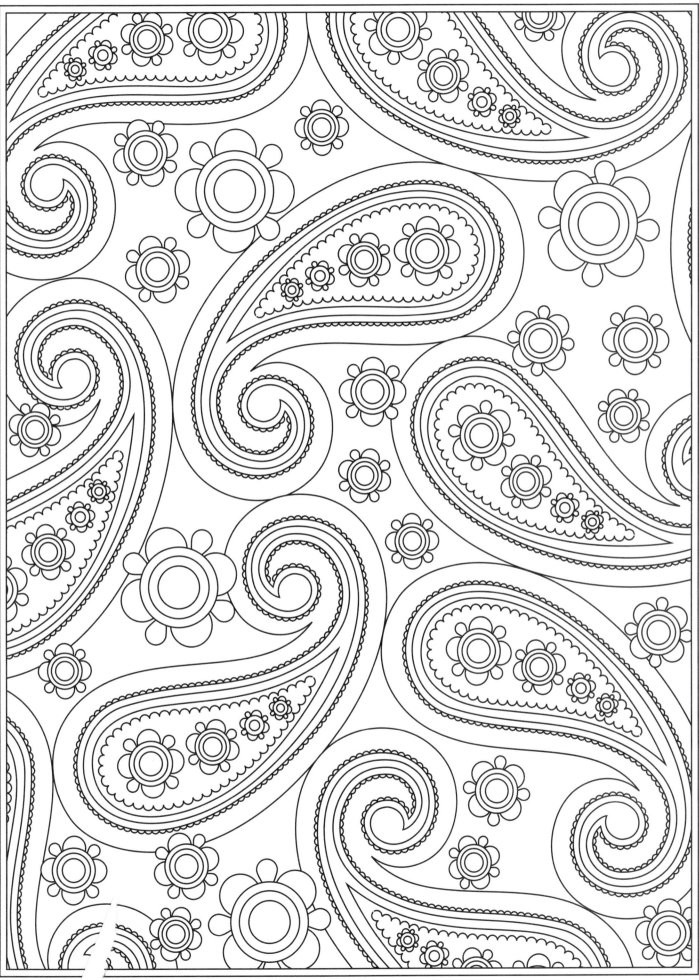

If you smile at me I will understand, because that is something everybody everywhere does in the same language.

—CROSBY, STILLS & NASH, *Wooden Ships*

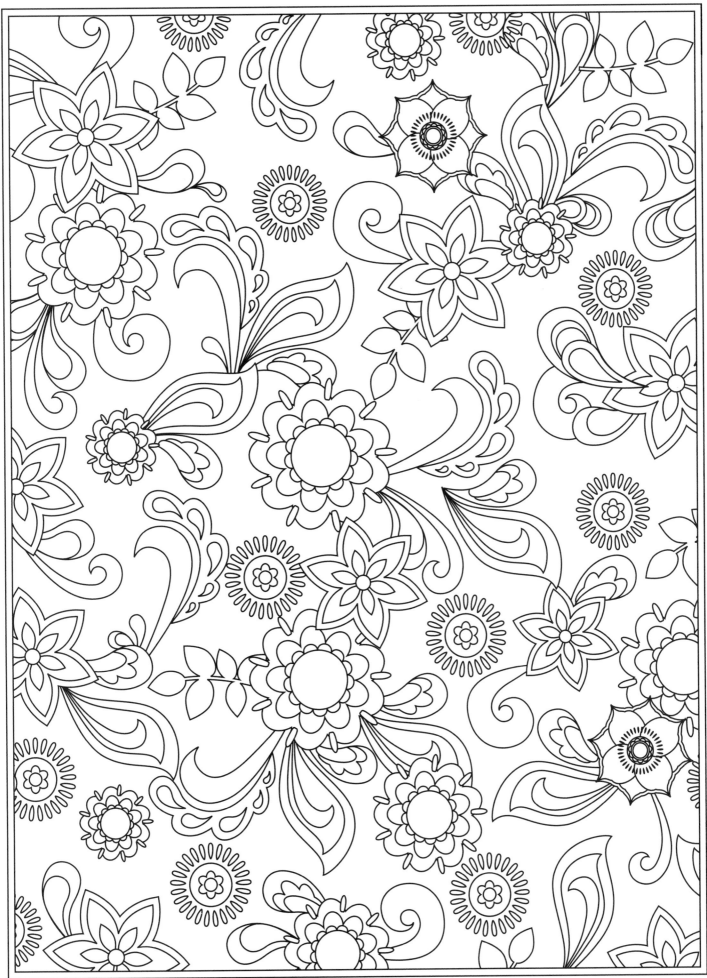

We are stardust
We are golden
And we've got to get ourselves
Back to the garden

—JONI MITCHELL, *Woodstock*

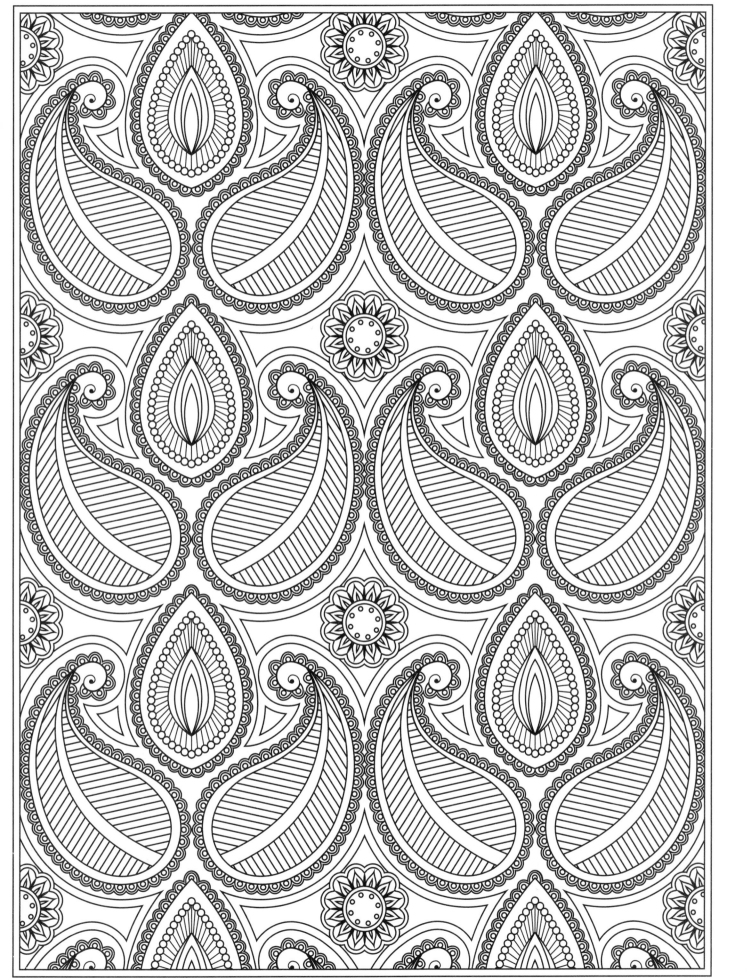

Great things are not done by impulse, but by a series of small things brought together.

—Vincent van Gogh

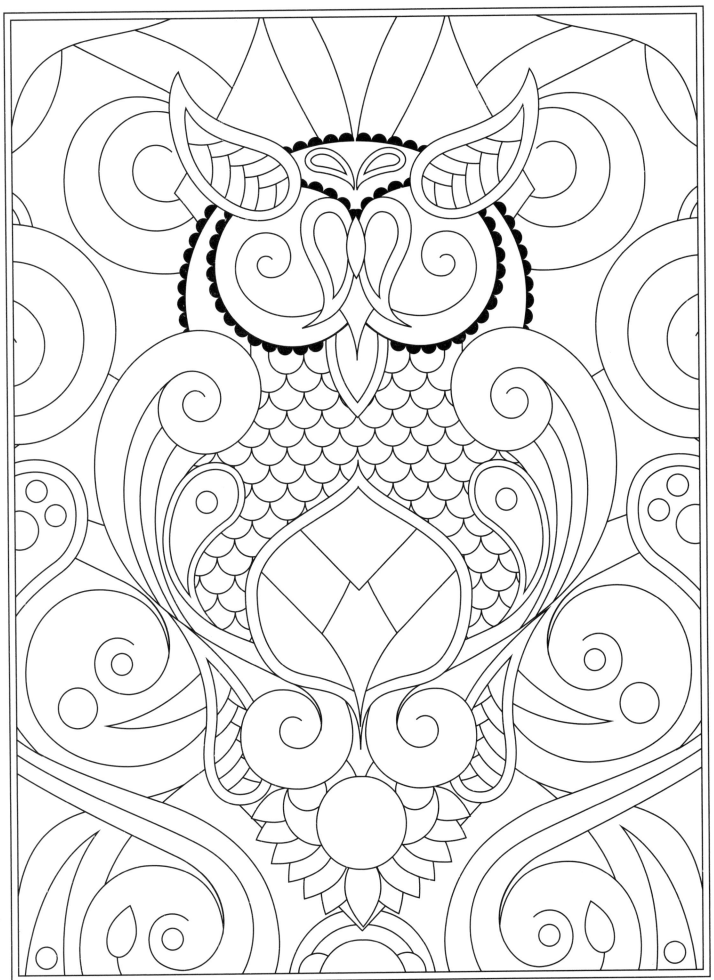

Like a true Nature's child,
We were born,
Born to be wild.

—STEPPENWOLF, *Born to Be Wild*

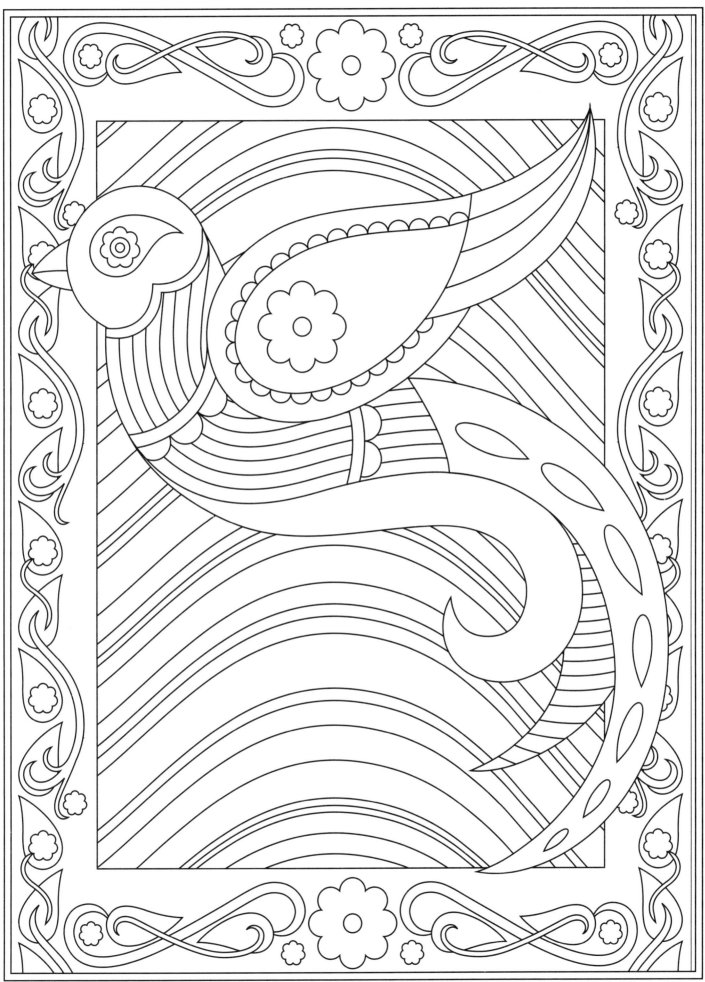

51

May you always be courageous.
Stand upright and be strong.
May you stay forever young.

—Bob Dylan, *Forever Young*

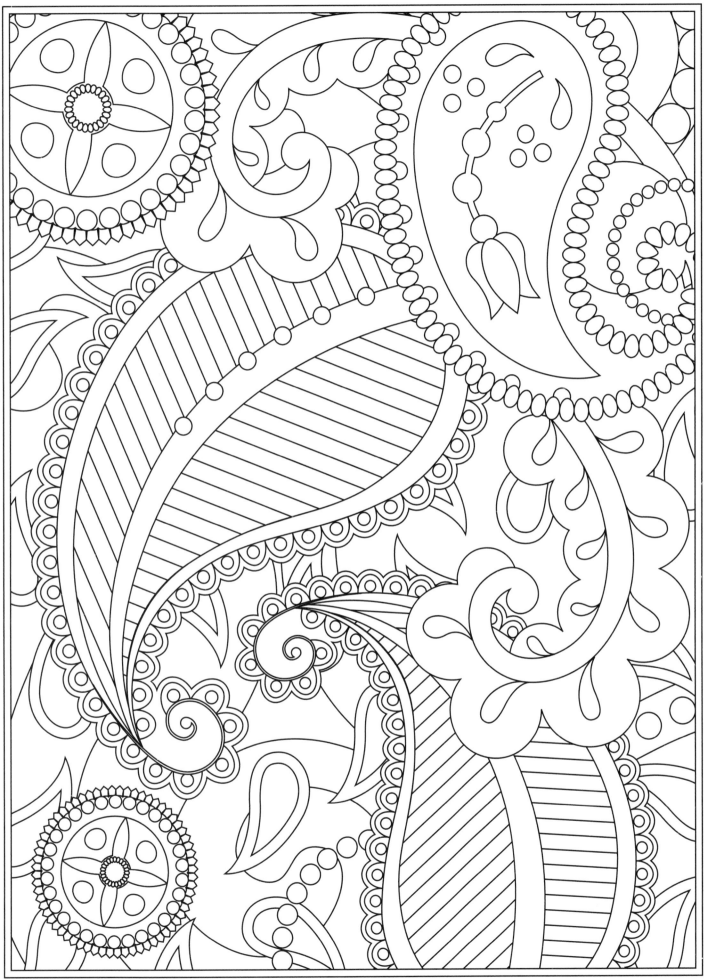

One love! One heart
Let's get together and
feel all right.

—BOB MARLEY, *One Love/People Get Ready*

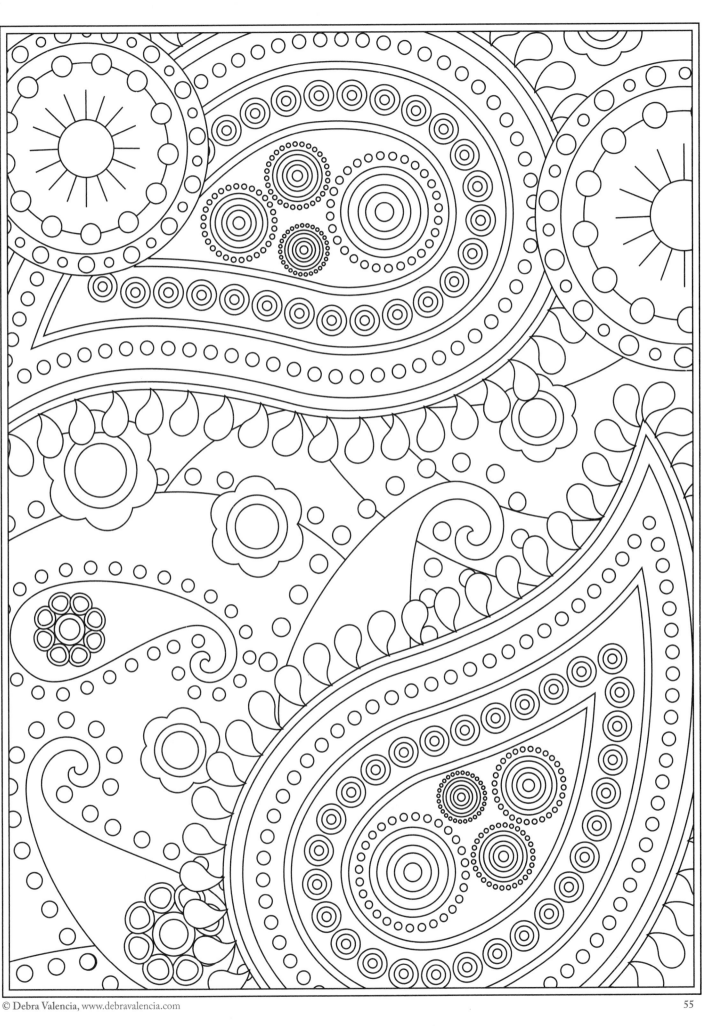

We are all wanderers on this Earth. Our hearts are full of wonder, and our souls are deep with dreams.

—Gypsy proverb

And in the end, the love you take
Is equal to the love you make

—THE BEATLES, *The End*

You only live once, but if you do it right, once is enough.

—MAE WEST

Don't worry 'bout tomorrow,
live for today.

—THE GRASS ROOTS, *Let's Live For Today*

The only way to make sense out
of change is to plunge into it,
move with it, and join the dance.

—ALAN WATTS

Go confidently in the direction
of your dreams. Live the life
you've imagined.

—Henry David Thoreau

When you realize how perfect
everything is, you will tilt your
head back and laugh at the sky.

—UNKNOWN

Remember that your natural
state is joy.

—WAYNE DYER

I want to feel as free
as the flowers.

—Unknown

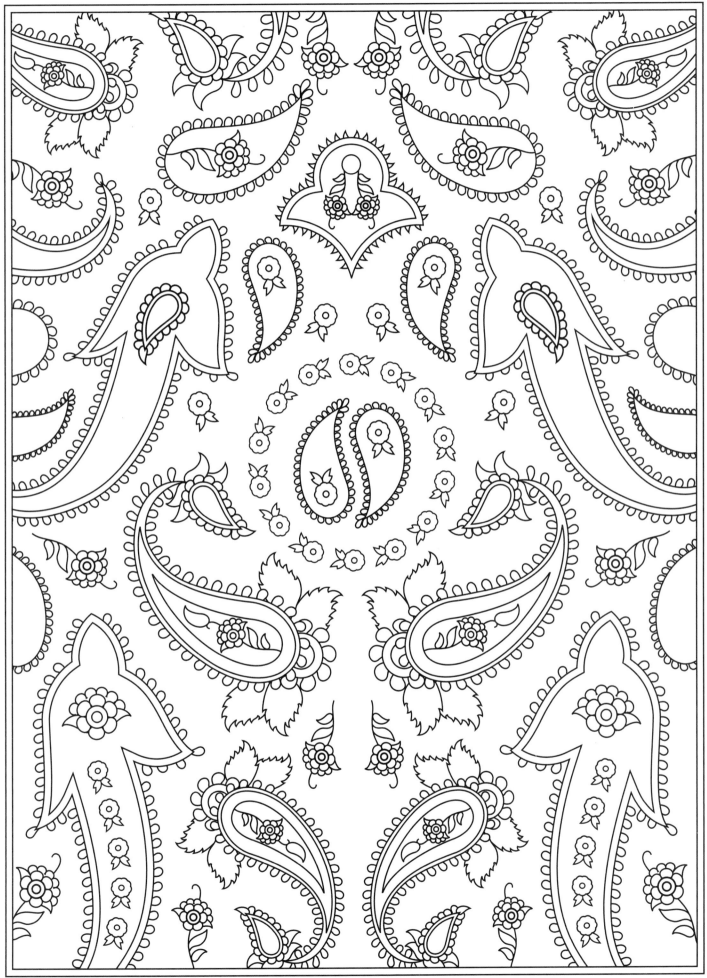

Look past your thoughts so you
may drink the pure nectar
of this moment.

—Rumi

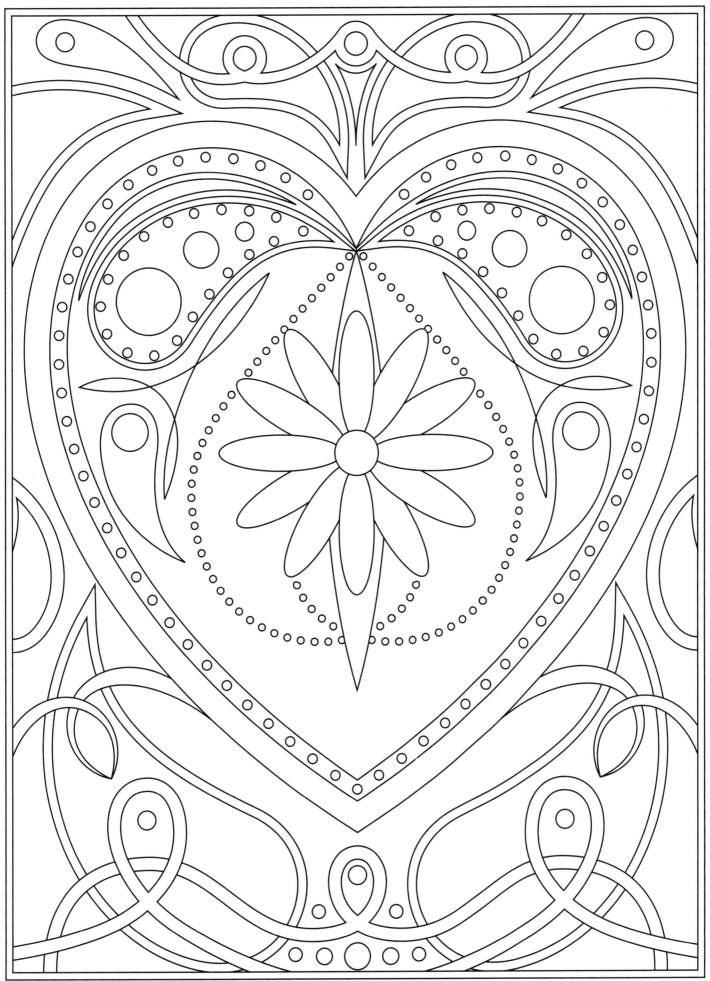

To live is the rarest thing in the world. Most people exist, that is all.

—Oscar Wilde

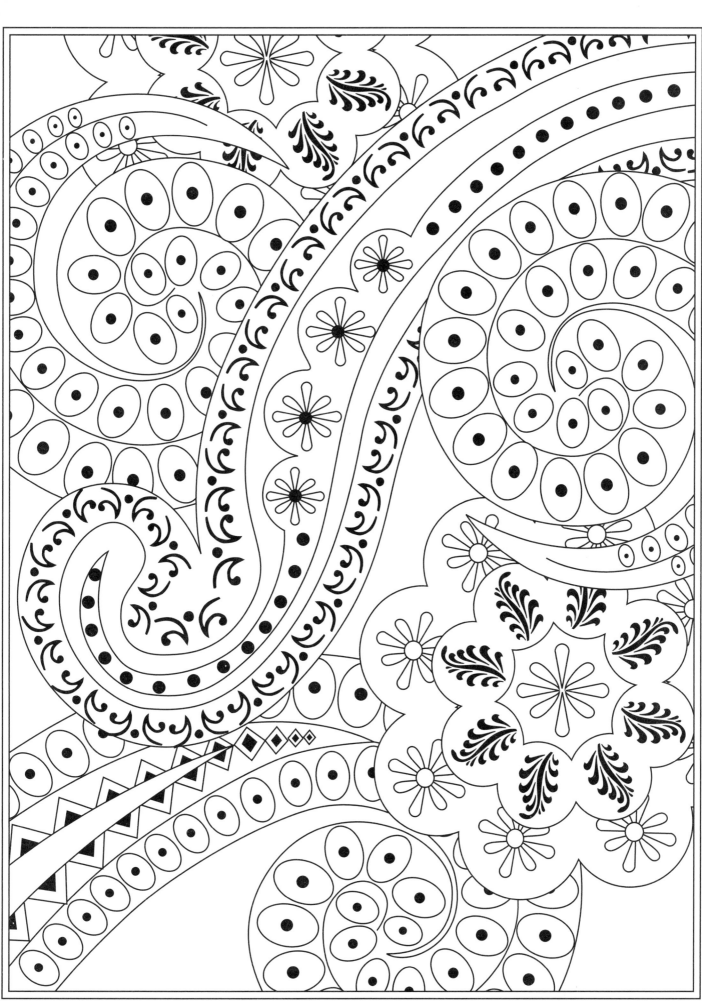

Let us dance in the sun, wearing
wild flowers in our hair…

—Susan Polis Schutz

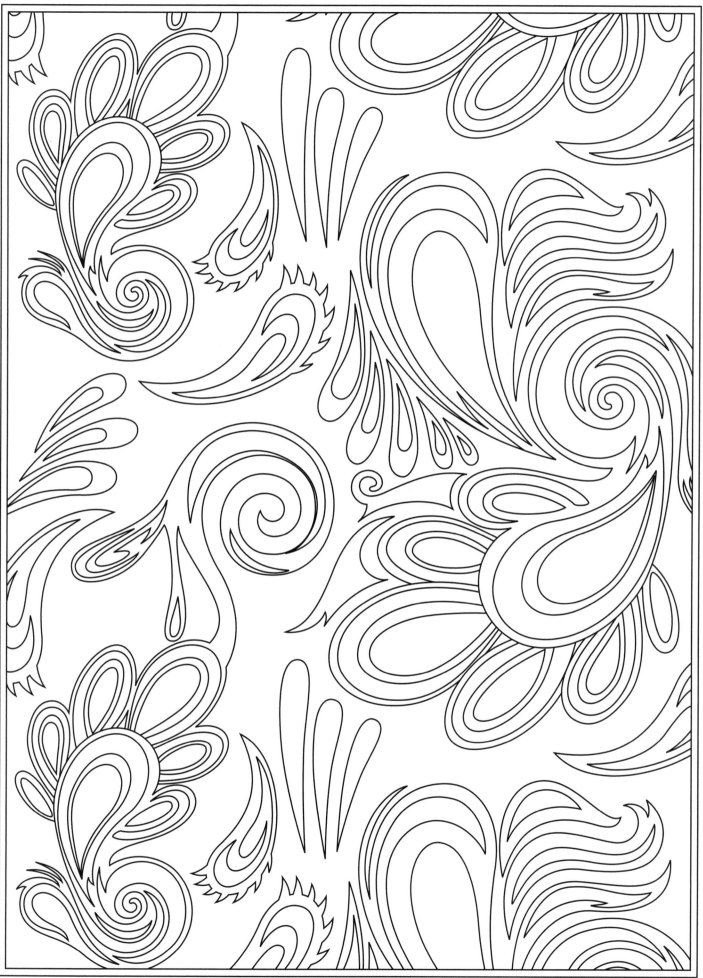

Life is like riding a bicycle.
To keep your balance, you
must keep moving.

—Unknown

